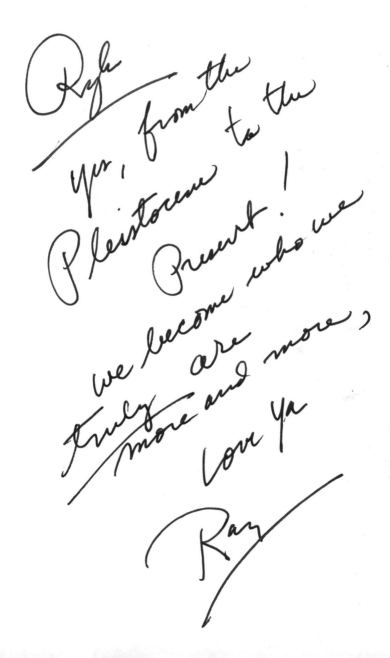

Ryk

yes, from the
Pleistocene to the
Present!

we become who we
truly are
more and more,

love ya

Ray

"Ray McNiece arrives late at night, in the loneliest part of the city, at the intersection of Blake and Whitman, Crane and Lorca, Kerouac and Corso. But the road he leaves on is very much his own; it's a path that threatens at any moment to blossom from mean street into mystical highway. It's the hard-earned route from experience to revelation, from bitter nights in cheap hotels to sweet returns to the roads and rivers and people of the Ohio home that always calls him back. Perhaps his best reader would be Charles Wright; it's hard to think of another poet whose voice can range so easily from a bleak vision of words, of poetry, as "the stained futon on the curb," to "the little mortalities / we try lighting like a hatch / of mayflies on the creek / swallowed by a trout / with a faint, ringing kiss." He's a poet who knows the best and worst of our cities, who sings the bus station and the art museum, whose love of the country and hatred of what's destroying it echo beautifully throughout this collection's elegiac title poem, set on Ohio's Chagrin River:

May the river devour these private property signs.
May the kingfisher skim open the seam of day's surface.
May the killdeer's skittering cry among the shale banks
Greet your children when they come to skip stones.

I can't think of another writer who so thoroughly convinces you of the truth of everything he has to say about the soul-killing mindlessness of manual labor, the beauty and absurdity of love, and the absolute necessity of art."

-George Bilgere, John Carroll University

Other Books and CD's by Ray McNiece

DIS: Voices From A Shelter
(Burning Press)

The Bone-Orchard Conga
(Poetry Alive! Publications)

The Road that Carries Me Home: Poems
(Bottom Dog Press)

Mouthmusic (CD)
Ray McNiece and Tongue-in-Groove

The Road that Carried Me Home (CD)

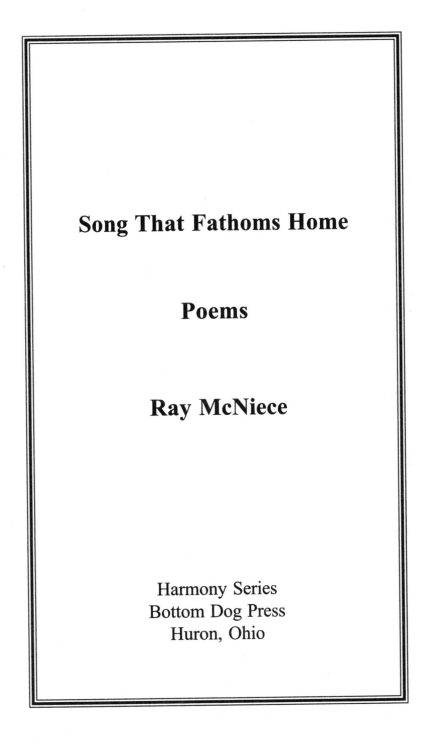

Song That Fathoms Home

Poems

Ray McNiece

Harmony Series
Bottom Dog Press
Huron, Ohio

ACKNOWLEDGEMENTS:

Thanks to the following magazines, journals, chapbooks, broadsides, and e-zines for first publishing the following works: *ACM,* "Harold's Resurrection." *ATELIER, "*Elegy for Samuel Beckett." *City Lights Italia Chapbook Series,* "The Word" and "Memorial." *CSU Anthology, Silver Apples of the Moon: Images of Art and Poetry,* "The Power of Music. " *Desire Street,* "Hunter's Moon." *Heartlands Today,* "Some Music that Fathoms Home" and "Cleveland Winter." *Listening Eye,* "The Last Pheasant Seen Hereabouts." KSU Hart Crane Award 2001, "Bird's Notes," published in *Icon. New Laurel Review,* "As We Fall Again." *Shining Our Light, Poetry and Memoir on the Experience of Mental Illness,* "Tearing Lines of Verse from Air." PWLGC Chapbook, *Dry with a Twist,* "155 Pounds of Dead Fish." PWLGC and Zeitgeist Gallery's Exhibit, *Prints and Poetry,* "Swirling." *Wayne State Review,* "The Picture in the Shoebox." *Z-Miscellaneous,* "Elegy for Andy Warhol" and "My Tongue Has Never Forgotten."

Table of Contents

Song Always Beginning

The Cheap Hotel Suite

Song Heard Only Now After Gone

Song That Fathoms Home

Song Always Beginning

Song Always Beginning

I. Winter

Song always beginning
from winter's gray maw
sparsed with branch clatter
recalling the lush hush
of summer when the river
deeps sounded bass-lines,
strumming now slowed as
hollow, crystal cello pull.
Blackbirds lift from wires
against the slate sky
like cracking scattered notes,
and the wind plays nooks
and sills for this ghost
sonata of last leaves scuttling
over snow-crust fields.

II. Spring

Then the ground-swelling
thaw and sudden surge
of one redwing blackbird
perched amid bending
cattails, as he calls notes
as sharp and vibrant
as red patched shoulder,
improvising a round
to bring mates near.
They say there is no
ode to joy in this age,
blotted out by atrocity
and necessity, and yet
song finds its way out
today through a gray man

who licks spit over reed
of his thin, worn clarinet
and lifts a tune through
the new leaves. A *lieder*
by Schubert, he tells me,
"a song from my youth,
Der lieben liebe
das wandren," smiling,
on his pale, bare arm
a blurred blue number.

III. Summer

Pink-clad teenage girl
on the bus snapping gum
to punctuate humming
a tune on her walkman,
gets off at the next stop.
Worn brakes screech
and hydraulic doors exhale
over the market's bins
of oranges and tomatoes
making a chromatic chord,
the pang of things bursting
from skins, as a mother
gives her son a banana
and he dances, "nana,'
nana, nana," footfalls
percussing the street.

IV. Fall

Old hillbilly fiddler
up on the porch
snugs grain of wood
under grizzled chin

and recalls an air
played in the kitchen
when they moved the stove
to clog the piney floor.
The tune skirls all the way
back to O'Carolin's harp,
takes shape and tails off,
as he recalls the time
he played it for her . . . again
he presses fingers to notes,
horsetail bow to strings,
pulling together—just so
they touched and trembled,
grace notes passing
so much like passion,
he plays along as it goes
and it goes just like this...

In Cold Light

I used to read in the basement till dusk,
sifting through musty encyclopedias,
exhuming history, trying to breathe in
how we each thin out to nothing.

Years later, walking far, I happen across
an orchard and half-empty pond on a gray,
late afternoon in the middle of November
doing nothing. No chance of snow. Windless.

The water still, reflecting the sky.
If this stand of bare oaks tells of loss,
or this farmer's dam, boulder on boulder,
not another sound the rest of winter,

the place holds absence like the stone
arches of some 15th century Cathedral
in Yugoslavia where a monk pigeon
rests famish-winged on a black sill,

where in the dimming light of day,
an anemic, babushka covered woman
enters, signs, kneels varicose
legs, brings hands to face and prays.

Prays for her husband and lights candles
that flicker in red glass. In this orchard
where evening light hangs like incense,
the bare trees, like books, hold silence close.

The Home of Lost Words

Try the door. Locked.
Look in from the stoop.
Two pairs of wing-tip shoes
line the hallway,
worn down, but shined.
Pressed suits nobody
will grow into hang
in clear, plastic bags.
A suitcase a boy
could sleep in
sits by the door.
The table remains set,
the beds stay made,
and the windows shut tight.
The air hangs as still
as the space between
ticks of a clock,
ticks of a clock
pace the absence.
In his father's house
are many rooms—empty.

Try to turn
away, try the door
again, try to find
the boy in the corner
rocking knees to chin,
moaning the *0*
of origin to *No,*
making a room
of the word.
Listen to the boy
who prays, *please,*
please, God,
for the dead father,
god balled to a fist

beating his chest
till he falls asleep.

For seasons after
he listened inside
the rain's
long, gray lessons,
scribbling them down
waiting for one
drop of sun to ring
trees green again.
Many dawns his dreams
led him through bare trees
spelling charred letters
of a forgotten language
to the small valley
where thawing floods
left the house moored
in a clearing,
doors ajar, creaking.
All the lost words
perched black
on the broken
spine of the roof
rising as one
wheeling sentence
disappearing
with nothing
but the sound
of wings
upon waking.

The First Word Spoken

The first word spoken
sounded its own death.
The second also passed
away and so on, just so
we talk like the dawn
rain's silvery cadence
whispering over this tent.

Last night I shook dead
pine branches in the fire,
needles crackling, pin-
wheeling upward through
the hemlock dark clearing
orange then gone, in—
visible as the star's dark
as it dies from the source,
as our love moans also
drowned in the woods.

Now wind soughs pines,
and the bird's black
body against the sky
dips a bit and flaps
up again out of sight,
sharp chirp echoing
so we mimic the call
making music of this
absence-to-be
to keep us company

till the day clears
and we can hike on
without talking much,
the little mortalities
we try lighting like a hatch
of mayflies on the creek

swallowed by a trout
with a faint, ringing kiss.

Monody for a Small Town

Nightwalking, scuffing
down side streets,
empty, I hear a cello
ahead in the thick
bloom of elm shadows
around these porches, pulling.

I listen as a stranger's
fingers squeak over strings.
The hollow body's sound
flows from one open
window, then another.
You cannot tell where
among these close houses
it is coming from, so alone.

And then I fill
with melodious loneliness
that holds at least one other
awake and straining
free and pulling again
in our dark home in time.

The Sun Pronounces

The sun pronounces
each tooth of leaf,
every silvery edge
of grass and highlights
the blue-green spikes
of the juniper
where my shadow
blends into shade.

A flute startles
over the breeze.
Whoever plays
stays hidden
up the hill
behind a hedge
blowing being
wholly melody,
stuttering to bare,
valve-huffing
nothing.

The tune gathers
again, wafts and
dips, blown
to bright motes
in shafts of sunlight,
as crows take up
their caws from
the dead branch
of a bare oak
like dark mates
of those notes.

Tearing Lines of Verse from Air

Honest to green life from the ground up, man,
you need to be rock-a-byed in mother branches
till the saliva stops running from drug-clenched teeth,
and they unwrap you from sanity's whiteness.
One rant too many brought the authorities pounding
on your door to take you away for your own good.

You were tearing lines of verse from air, spitting them
out at the walls of the city, but they ricocheted the room,
and you got caught in your own crossfire,
pausing only to push up thick glasses empty as
lithium bottles except for those two angry flies
staring back as you cursed the mirror.

You knew you were no better than others, never
considered yourself worse, a threat. Polite teachers
started the bleeding from thin skin with red ink.
Write as if objective. Now you write from a room
as clean as electricity. Slick as jelly-smeared temples,
you scribble, "fly, fly, fly" on every line of every page.

Afterwards, faces on the street froze like bomb blossoms,
shriveling dark as garbage bags in a drum fire.
With one stare, they screamed inside you for days.
When you got home, you soaked your head in the TV,
stronger doses keeping the sirens farther away,
flies pinging tightly against glass, whining in webs.

As boys we wore hats of broad sycamore leaves,
the cool green soaking in, and waded Chagrin sloughs,
holding the shudder of iridescent sunfish
before releasing them back into the deeps.
It wasn't till years later you felt the hooks
and spoke carefully from your scar-tissue mouth.

Truth of Breath

You wake up
from a stupor
maybe once
every forty days
or so and look
around to see
where the hell
you are after all.
The wall of fame
shows you heroes
before the geezer
in the mirror gives
his goofy smile.
You look down
at stained pajamas.
It's no good now.
Yeah, once every
month you surface.
Maybe symbolic.
Anyway, a raft
washed on a reef
in the middle of
flat, blank days
out in Idaho.
Today it would be
easier. You could
simply forget how
many pills you took
and take another
hand full, small as
pellets, and never
wake back up.
But all you had
then was drink
slurring it together
and a shotgun

for your banged up,
punch-drunk head—
all those shots
of whiskey and bare
fists landing again
until you're back
in your corner,
and him, the man
you made of it,
sits waiting in his.
Him, with his four
bad marriages
bullied into failures.
Him, dressed in
a dress as a boy.
Him, posing beside
a swordfish twice
his size, draining.
And you, simply
trying to put one
good word after
another like baby
steps by the end.
But there he was,
knocking them out
of your beard before
you could say them,
leaving nothing but
the truth of breath
and stark silence
like a hammer cocked.
But the saying of it,
Hem, brutal as it sounds
is always worth it.

Whitman in Manhatta, 2000

Uncle Wally, where have you been?
Your layers of Goodwill scrounged coats
exhale 3,000 miles and back of road
weary wonder at America's sojourn.
What did you have to wade through
with those garbage bags wrapped around feet?
Where did you find that hat
stuck with plastic flowers
as you promenade before the display
windows of this chic, hyperactive amusement park
island of capital and culture?
What's that muttering through your ripe
Rip Van Winkle beard
about the cosmocracy of the demos?
Did you ever find your lover
out there in the fly-over, test-product states?
And what, by way of Madison Avenue and Hollywood,
did they try to sell you
so you could fit in to their latest trend?

New York, your weird prodigal
son has come home to roost
on a heating grate.
Now he extends his rough hand
to bless passers-by or at least stem
a little 'social' change.
What are you afraid he might contagion you with
that you keep such a distance?

Old Camerado, I follow as you slog on
through pop slogans blaring
from the walls of Time's Square,
CONSUME, COPULATE, CORPORATIZE!
I see you whispering intimate free verses
in the ears of customers
in the half-price Broadway ticket line.

You know the show always starts here in the crowd.
Now you're blowing kisses to passers-by
through the hustle and shuffle of the economy's emissaries.
But this is America 2000, the one
with the most money at the end wins,
so nobody pauses to blow back one kiss.
No soul sings along as you conduct the varied carols
of the oblivious and the intense
as they hustle along under the skyscrapers'
loud and shining suits of glass and steel,
that one up each other
from midtown all the way to Wall Street,
shouting their power
like brokers in the pit
frozen at the bell.

But I see you smile anyway, Walt,
finding a patch of grass there
under your feet,
where you said you would be,
your baggy-wrapped boots removed
and your pale toes wiggling free
in the middle of Manhatta.

Elegy for Samuel Beckett

Under a gray sky,
a black bowler,
one side punched in,
blows, rolling down
a boreen as bare
as a shin bone flute.

Inside his Paris flat,
the half-empty tea cup
stares at the ceiling.
In the courtyard below,
prisoners continue
their jumping jacks.

Their arms flap still
against baggy uniforms.
Somebody's frayed pants
fall down around ankles.
We stay where we are.
Fade to dark.
Krapp coughs.

Elegy for Andy Warhol

The man who made a career out of being bored
has died in his sleep. Bury him
in a soup can, in a hundred soup cans.
He had more than his fifteen minutes and lived
that sentence the rest of his life.
Now he sleeps with Marilyn.
Eternity is a marketable image,
and heaven is a blond wig
clipped to his skull.

Bird's Notes

The more be
form of bop,
notes in-
tensified, shot
hot through
late night
hallways of bodies,
through rooms
of moans, vib-
rating window
panes
into evening
velvet.

When the combo re-
ceded, he went on
alone in-
to synco-
pations, the tot-
terring steps
to dis and
back up to
resonance
all gig long,
circling,
ending
as a squeal,
axe tilted up-
right,
fingered tight
as Charon's joints
on the rudder
steering across
the river of
forgetting,
then blown

again as shiny
and exact
as new
coins,
thrown
down
wet
stairs.

Even he
went along
for the ride
near the end,
chopping through
smoke,
chopping through
stale wine,
chopping through
walls of small-talk,
chopping through
his own boredom,
just to get to
those sharp,
bright points
of night
cause all
that waited
was dirty
needle sucking
and spitting,
and his lips
frozen
to that cold,
gold burning.

When he went
down his stops
sounded as

all time stopped...

his riffs ran
and ran
out of the blues
and wailed past
the present on
breath borrowed
from wind scouring
back streets
from Kansas City
to Harlem.

Bird's last notes
surfaced
like drowned men
who rise
once before
sinking in the dark
hole where sound
waits to happen
no matter
if it sounds
pain
blown
free.

Velvet Elvis

You want sex, drugs, and rock and roll?
Roll your rocks down to Graceland
and glide through the grace note front gate
where an impersonator in sequins and shades
banged open the door waving a 357 magnum
and ordered "Everybody get outa my house!"
Uh thank you, thank you very much...

You want sex, drugs and rock and roll,
take the tour to yellow, blaring TV room,
featuring a dozen screens of swiveling hips.
But you won't see naked groupies running
through the green shag jungle room now.
"Why did I carpet the ceiling? Because I could."
Uh thank you, thank you very much...

You want sex, drugs and rock and roll,
crack open the glass display cases of costumes;
slicked pompadour biker leather, rockabilly rig,
Kid Creole get-up, or Viva Las Vegas Cape.
Try 'em all on and take care of business show 'em
what a pot-bellied, cracker, trucker can do.
Uh thank you, thank you very much....

You want sex, drugs and rock and roll,
think about not being yourself anymore,
and talking to Elvis in the bathroom mirror.
But they won't let you see the King's last throne—
DEA special agent Presley sitting on the hopper,
spitting out pills, eyes finally seeing the glory.
Uh thank you, thank you very much...

You want sex, drugs and rock and roll,
buy a souvenir Velvet Elvis masterpiece
from the fat era, stuffed in a jumpsuit,
striking that 'Have Mercy' pose one last time.

"Feel that velvet, smooth as a donkey's ass,"
says the man at the back of his pick-up, echoing,
Uh thank you, thank you very much...

You want sex, drugs and rock and roll,
before you leave stand astride his grave
in the Memphis dusk and feel the roll rise up
from the earth and rock you back on your heels
till your hips can't help but begin to swivel
and your very pelvis seems to say,
Uh thank you, thank you very much...

Out of the Same Dark that Blooms Always

After turning with the usual insomnia,
I'm awakened by angelic voices
through the static of my cheap radio.
After a few swells, "Bach Choruses,"
I guess, and logic has solved the Deos
that crescendoed my thickening doze.

Piercing up between the hiss
of a talk show and the all-night news,
a cathedral echoing soprano vibrates
a solo through this plastic shell,
and other singers chime responses
of nearly extinct Latin grooving out
from a studio who knows where or
how it overflows my rented hovel
here in the middle of the city of Dis.

Out of the same dark that blooms always,
a sudden, golden Gloria Excelsia
breaks open and rolls along the hallway
lit by row upon row of tall candles
with Bach himself at the other end,
trying to get through the night as best
as he can, parchment scratches singing.

The Power of Music

from a painting by William Sydney Mount, 1847

Two country gentry have come
to hear the Irish stable boy
rosen the bow as he rests
near the stalls. He has started
another tune, and delight
arcs across every face:
the boy intent on the notes,
the older squire, seated, his heir
leaning against a wall,
and the freedman field hand
just outside the barn door
who had been chopping wood
to the beat of the last reel.
He has set his ax down
next to the little brown jug
he'll no doubt swig again
before stepping in to tap
across the floorboards
in a West-African style
as the men clap along
and the jug goes round,
follow the drinking gourd.

The gentry wear red ties,
a red scarf drapes the legs
of the fiddler's chair,
and the freedman wears red
suspenders on his overalls,
mopping his brow with a red
bandana he drops in his hat.
But it is all the blood of song
they stomp as the boy sings,
If you want romance
you have to take a chance.

The women won't give a glance
till the men get up to dance.
They go on long past
when the jug is drained.
Then each goes home
whistling the same last,
sad air the boy played,
the men with a musing
over what they are missing,
the boy forlorn for the wind
that shakes the barley-o,
and the freedman with a hum
deepening into evening blues.

Swirling

It makes sense now
to let beach wind blow
lost pages away

through susurrating grass,
and petrified stumps
of telegraph poles

gnawed by grits of sand
like skeletons of progress;
to let them scuttle

over high, rippled dunes
sucked into the inhale
of Atlantic undertow.

It's only paper, I say,
as grass whispers tenacities
under an overcast sky,

where a gull folds wings
on a gust and rights
its flight before lifting

out of sight. Breath catches,
choruses the surf and breezes
out to the horizon.

An umbrella tumbles by.
Comedy is an accident
happening to someone else.

But that one shoe
on the drift line
brings the sky closer

as the waves flash
and crash the ocean
into silvery sheen

receding, the page
of surf turning over
scurried piper tracks.

I hunker down
between clumps of grass
beside a crested dune

as the storm blows by
and gives way to suddenly
sunny, cloudless day

where I stretch above
head tall bleached stems,
seed heads swirling,

and open like a book
blank pages fanned by
the blue breath of sky.

The Light of Day

Prisms of dew outline the web
between window and sill, nothing caught
in that sticky alphabet of fate.

Bare feet thud the floor, cold wood
sending a shiver through naked body
that dispels the dream remnants

where a pale flame swam the dark
down to a crevice of lava, through
the other side, and out into flying light.

Open the front door and look down
on the stoop at the latest headlines
of the war and an inky photo

of a refugee smiling behind barbed wire—
around her neck she wears a tiny horseshoe
medal that wasn't melted into a bullet.

Open the mail to more bills
that need to be totaled and balanced
against your dwindling savings.

The math of Dr. Suess comes to mind,
one fish, two fish, red fish, bluefish,
a colorful school rippling over a reef

off the coast of a dying paradise
where maybe one day you will arrive
when all your debts are paid.

On the way to work you stop for coffee.
In the midst of small talk at the counter,
nobody dares bring up the war.

Outside on the corner, a homeless man
recites his poem over and over,
Spare some change? Spare some change?

As if he could stem the tide
of business as usual with his smile
full of god-bless-yous in the face

of a bus ad for a cell phone
can you hear me now? Bus gears
grind as the plume of his breath

swirls away on the exhaust,
the light of day reflected on the coin
in his palm where you both stare
before moving on.

The Word

Body stands as one breath slowed down,
thickened around the word stoked up,
crying as hungry for air as newborn
for blood thrumming milk of mother
tongue humming tune formed of moans
marrying groins with oo from roots
unto moon's pull, *uh,* coming home
to hearts that echo *ah* around skins
thumped and gut-strings vibrating here—
hear, around this circle where we speak

sparks from tongues like flints to kindle
the torch of song swung overhead,
embers swirling night so sight traces
syntax of stars that tell this tale of light
falling in love with dark, and their child,
the sound behind the word, spreads wings
filling lungs with fiery names of things
that sing passion buzzing cups of Spring,
that dirge sorrow laying stones on graves,
that resound now to the drum *OM..*

But the word learned to lie through a smile
of fangs, let itself be sharpened to a point
and stuck in the music of pulse so *NO!*
stays frozen open on mouths of enemies.
It fell in line behind numbers to monument
empires from tombstones, and marched like
charred sticks across yellow pages of history,
only to suffocate again under library stacks.

But the word rises and refuses to sell
this naked howl for only the letters of law,
or cower under the pall of headlines,
or click and flicker inside screens.
It speaks one wild seed that says *green,*

one drop of sweat cooling dust risen,
one crust of bread broken and shared out,
one blossom tossed in the path of death,
one poem that knows the teeth of the poet
will outlast any new sounds lingering.

So the word wends through the shambles
of Babel, dowdling from ragged bones,
merrily, merrily, merrily life is but a ...
so every one in line at the bank joins in
the round, *dream,* and the hustle stops
below the pyramid scams where every I
wants the spotlight glare and sound-byte blare
that can never drown out the simple lyric
down here where breath steams and streams.

Taletellers ran bone-ropes through tongues
to watch what they say. Bards were sewn up
in sacks and hung over an abyss three days
to think before they speak. Seanachies wore down
unshod feet bringing the ghost chorus present.
And the muse unravels veils of silence
in the midst of this din of dis and kisses
the word full on the lips so there is nothing
between breath and truth set free.

The Cheap Hotel Suite

Cheap Hotel Suite

I.

Only two things
I never want to do—
hurt my friends
and die in Houston.
I'm broke and down
at the Y downtown,
hearing deep breathings
and headboard banging
on the other side
of an eardrum thin wall.
Moans blue as neon
flash and hum through
cracks webbing the ceiling
like a map of nowhere
and you are here,
the definition of alone.
The only other thing
inside these four walls
is my breathing, flapping
wings against window pane.

II.

Hotel Essex sign burning
out but flickering HOT SEX—
as if this tenderloin flop
needed more advertisement.
Down on the corner
her fish-netted legs merge
at the intersection of desire
and survival and carry her
back here tomorrow night.
I keep the bare light off.
Its filaments jiggle
like cockroach antenna,
casting frantic shadows.

I push the remote button
again, trying to find fleshy
puffs of electrons so I can
pull light from my body
glowing blue. Turn it off.
Hearing becomes a whirlpool
of erotic debris, a delicate
soufflé of decay, and the world
is still turning like a ball
of grease spun by a roach
stuck on its back in the corner,
HOT SEX shining on its shell.

III.

One of those nights
you feel infinitely
singular, the room
not anyone's home.
Naked light hangs
executing objects into
sharp-angled shadows.

A pile of dirty clothes
like some body else's
humps the floor. You drain
a flat beer, piss till the
last tears echo the bowl.
The roll away bed is
as narrow as death's door.

As obvious as the face
of the pockmarked moon,
as the face of the clock's
ticking stare, it will be
one of those nights
you have to crawl alone,
all the way till dawn.

There's a black land under
your skull you'll walk
till you can't think one
more step. So you sit and
warm hands over that first,
that last spark, blowing on it
as dim faces glow and fade.

The moon makes the chairs
tombstones, so you tell them
your troubles. The dead are
simply dead and you just
love them for it, basking
on their backs, eyes glinting
over all our beautiful futility

IV.
Hours meet one
by one, face to empty
face, the walls and ceiling
the same tomb blank.
Flat on my back holding
space open mathematically,
the meat clock beats
through the dark—drink
won't keep it quiet.
If only a lover could
come and quicken flesh
into momentous oblivion.
But this mattress sag
is a merciless embrace.
"Bed" has become an empty
word, like "woman," like "gone."
It makes only a dead
rhyme for both my heads.
Once we dreamed whole
erotic novels, turning page
upon page on these sheets.

Now I'm a bookmark
in the Bible of guilt.
Our bodies are memories
other lovers sound as they
clash blood cymbals.

Twirling a Paper Umbrella

What's my problem, Mister?
I am in my own extreme
pain and pain has a way
of calling attention to itself.

So excuse me while I tell
the thumbnail tales holding
on around this bar full of
"how did I get here?" stares.

Like him knocking back
shots and barking at her.
She can't or won't hear
a word of his in this blare.

That one wonders where
it could have gone wrong
into her sex-on-the-beach,
twirling a paper umbrella.

You can see his gears,
stripped, fall into place,
shift into another script,
only to slip back again.

She triages ex boyfriends:
those with half a chance,
a big pile of maybes, and
them that ain't gonna dance.

He's eager. She's angry. They are
both looking for somebody
else to hold onto tonight but
never again each other.

This one holds out singles,
flags of drunken surrender.
This guy counts his wad and
folds it quick and tight—

a chance to flex, ready to fight.
She can't stop looking over
her shoulder. "Hey you!" ricochets,
and glances pinball the room,

"Whadda you lookin' at?"
He's a thick exclamation point.
The other stays sitting duck,
a hunched question mark.

The crowd shuffles an ellipsis...
as the barfly sage in the corner
guffaws, coughing off on a jag,
and the drunken buzz builds

back up till finally last call
is yelled. Mister, this ship is
sinking. But the S.O.S. Goodtime
will rise tomorrow at noon

with skeleton crew intact
fueled by coffee and aspirin,
setting sail 'round Cape Pain
towards Port Hope again.

And she'll be sitting on deck
twirling a paper umbrella
as evening stretches before her
over deep blue swells.

Valentine

Love — Ha!
Throw all the Romeos
and the Juliets
down its maws,
dozens of dead,
red roses, suitcases
crammed with crumbling
yellow letters
of bachelor uncles,
and spinster lyrics
stuffed under
moth-eaten lingerie,
toss stacks of blue circled,
red x'ed singles' ads
into its churning guts,
all the lost vows
and last phone calls shouted,
and still love
wants more.
It will take
the chocolates
from your cardboard heart,
bite into each, tasting
for that sweet something,
then stick them back
on crepe paper cups
to harden, the red foil
reflecting its leer.
O there is no love
without this devouring.

The Chianti Flute Solo

My empty clothes scrawl
behind across the tundra
floor of moonlit bedroom
in this last ditch attempt
at sleep gone insomnia.

I stare at the square
of light glaciering down
the wall over roses hung
by their heels like
forgotten convicts, over

the blank, dust outline
that only makes her face
linger there more, over
the row of spluttered out
candle stumps on the sill.

There's not a drop left
in the bottle, let alone
a note, but I blow anyway,
"The Chianti Flute Solo,"
stale, hollow nothings -

and the moon is nothing too
but a cold, burning $n0$.
No, it's just an aspirin
I can't even reach to swallow.
Besides, ain't got no chaser.

155 Pounds of Dead Fish

This morning I am this bowl
of cold oatmeal,
and the spoon scraping,
echoing the empty room.
The sunny-side up eggs
eye me like a sadistic clown.
My coffee breath writhes
and hangs stale in front of me.
All I have for company
is yesterday's bad news
set down in neat,
matter of fact columns
of ink that sticks
to my fingertips
and smears darker circles
when I rub the crust
from my eyes. All the golden
light we swam
when summer flowed always
rots inside now,
155 pounds of dead fish
and their blank stares.
I gulp the last
of the coffee for what
little zip it shoots
through my veins.
The clock arm sticks
and jerks. I have nowhere
to go anyway but work
and back. My tongue goes,
blah.

Did I Trade You For the Moon?

Did I trade you for the moon?
you asked me once and now,
full again tonight, I'm drunk,
trying to focus the double zeros
of fool into one shining face
surfacing from the pond of night,
that haughty upturned tilt
learned from your nun-trained mother
that turned so easily to sorrow.

Did I trade you for the moon?
you asked me once and now
the wound of distance shows
how close we came in Greece,
that last party before parting,
of holding forever. But that man
across the table wanted you too,
and all I could see was the pearl
earring setting off your round face.

Did I trade you for the moon?
you asked me once and now,
full again tonight, I walk out
of this motel room and call to you,
staring up over miles and years
of not seeing clearly - no answer.
Easier to leave love hanging there,
the cold center of a blank mirror
that reflects neither of our faces.

Did I trade you for the moon?
you asked me once and now
no chant of that can conjure
your face shining disdain.
Nothing but a filmy eye stares
down as I wade chill surf.

A crab pokes through crevices,
stalk eyes, spindly legs and claws
searching, maws ceaselessly chewing.

The world is this hunger, and spasm
of wave crash as foam glows over
the crab scrabbling backwards
into hiding and my body wants
only to be taken apart bone
by bone, soaked in dark fathoms,
gathered in surf and thrown
ashore to spell, *empty,*
and rolled again to spell, *free.*

Poem of Emptiness

This is the poem I never gave you then,
written by your footprints on the beach
across the skeleton of the half-moon
washed ashore, picked clean, worn thin.
My hands have given up trying to join
these scattered shards into a necklace.
This is the tear at the bottom of the ocean
hard as the pearl pinching your earlobe

This work no longer in progress once
stretched 3,000 miles between two beds.
It's been edited down to one solo scrawl
under window framed stars whereby
we charted horoscopic connections, fire
burning now as glyphs of forgotten tongues.
The dead birds of this poem drop dead
from loneliness coast to coast.

This poem sags like the stained futon
on the curb, like the one chair in the bare
room with the last note tenting atop.
It keeps the silence after echoed shouts.
Sits like a candle stump melted on the sill.
Sounds empty as champagne punts thudded
together in the aubade of the garbage man
banging open dawn, clanging it down shut.

This poem can no longer remember
your phone number. It is too tired to
call out your name in the middle of this
or any other night. This poem is nothing
but the dry fountain in the last garden
lifting nothing aloft. It is neither rose,
nor stem, nor even thorn. I give it now
only as I must inevitably give back breath.

Only Now Alone

Only now alone
do I look around
this empty train car

and see that I
planned it this way,
so there could be

no return. So I turn
to the iced window
and look a long ways out

over winter corn rows
into that farmhouse
where no-one lives

but in memory—how far
away it is, farther than
I ever imagined before.

As We Fall Again

Over the autumn evening hillside,
the sun swells as ripe
as this pear. We suck juice
from each other's
mouths, and I push
inside you like a hornet
into sticky pulp,
drone drowning
in such last sweetness.

Our shuddering embrace
releases us from bones
into breathlessness
as we fall again
over the rooted earth
where we will end
in branches, bare
then blossoming, marrying
soil to stars that open,
from darkness,
delicate light.

Our Bodies Joined

Our bodies joined in proof
of youth, I dreamed our decaying
beatific-putrid lips bursting
kisses, fermenting genitalia
splitting as we fondled down
to our bones tangled in a bed
of dust blown through the stars.

Not the sham of back-less
funeral suits and dresses as we
lay stored in metal caskets like
canned goods for eternity;
nor plastic bride and groom
atop hardened wedding cake
stuck in the attic of memory,

but a menage a trois with death
smiling through faceless skulls,
our empty ribcages enmeshed,
sharing the pulse of darkness
through the empty dream of night.

Just Like That

I've just met a woman from another world
who wants to rescue me some night from
my empty bed and I can barely contain my self.

I almost skip as I cross the deserted parking lot
towards my rented room when it hits me—
I could be bludgeoned by a tire iron right here.

It happened before, just last week. Splat!
Just like that. Life as I knew and dreamed it
all over the concrete pavement. All this desire,

dog food picked apart by pigeons in the morning.
The skull's aquarium shattered and the quick,
bright fish gasping out. I'd be a chalk outline.

A bad news article justifying the neighbors' fears.
A greasy smear in a week that others walk around.
I know a violence like never before could descend

any minute and obliterate every lover's face
and their small talk of happiness, what with that
doddering puppet of a president in the White House,

quivering finger poised over the button.
But I return to bottle shards in the parking lot glinting
in the streetlight like the wreckage of the stars.

I hurry through the hole in the chain-link fence,
key in hand, lock out the night and climb into bed
where I can hide at least till the dark turns nightmare.

My Tongue Has Never Forgotten

My tongue has never forgotten
your barely, your curves
savored but unable to save
from slipping
out of dream into
an empty bed. I remember
quicknesses and slows
of skin, the concurrence
of endings beginning,
each of our brieflies
fastening into sweet
descent where we meet
our mortalities
reborn.

Intimate with your between once
I long again
to plumb the nether
with you further.
Simply the permeations
I crave, the mmmmm
of arousal's ebb tide
that others smell,
wondering what
primordial waters
we've been swimming.

To tell all we found
and gave away in the now
of love takes slow
touch, and tonight you are
nowhere near and
my innuendo is so
always yearning, come
home, come and anatomy
this memory.

Four Sharings

1.
Down earthy through and through, love
comes spreading this aura of surety,
articulating instinct with our hands
where each touch arrives original and
genuine, neither yours nor mine.

Woman, the finest veins of your thighs
release—your pulse, rose upon rose
opens and overlaps with a fierce
rush that comes from the thick of you
shuddering outward, blooming above me.

2.
You take only so much
when I complain and stomp
around the kitchen,
haranguing the this, the that,
pounding the world
like it's a basketball.
you tell me to shut up
or get out. Later,
as you sway tip-toe,
wash-banging pans,
singing reggae,
I slide in, sit
at the table and wait
for a slice of pie.
But you swat me
in the nose like a bad
dog, and pull us
back down to bed.

3.
No more time for no. This is the yes, to kiss
your blond flower over

and over, to rub lust
and smooth what comes
here and now to have
and hold till the room
breaks open, and we black
out—there is no other
joy like this joining.

4.
I lack you like this field
needs rain, like the mud
could use a river rise.
You walk naked through
grass the color of your sex,
your nipples peach blossoms
just burst as we swirl
the cool eddy of the river,
riding spirals to the primal
tune of blood quickened to
this heaviness afterwards,
that bliss of gravity is only
the soil calling us to sleep,
to dream within the same deep.

Twined in the Dawn

Twined in the dawn,
in an always now
so neither knows
who's who but flows.

The alarm buzzes,
traffic jam updates,
latest disaster news —
just wait a minute!

We will rise today
in our own sweet time,
two green wings
of one body.

Hometown Haunt

Man, I'm in a pickle again the likes
of which only that slump at the end
of the bar next to the jar of embalmed
eggs could mumble as a name lost
one more last time before sinking again
as the wreckage of my own latest disaster
drifts by like that spent passion fish
in the dingy algae aquarium as I sip
Irish shipwrecks, whiskey on the rocks,
washed ashore in this hometown haunt.

A couple haggles details of impending
nuptials in a back booth over a table full
of empties, specters of divorce lawyers
looming over their shoulders—meanwhile
I notice mini-skirts have come back in style
as I follow her legs all the way to the
smile she gives me before straightening
up to give her boyfriend whose tattoos are
as big as his biceps a better look see
at whose eyeballing her. I nod. He glares.

Luckily two ex jocks are about to butt
beer guts at the bar. They slam fists
and bottles on the sticky mahogany,
barking back and forth that foregone game
woulda put us in the state championship!
that bootleg, reverse, end-zone bomb—
Dropped! They jab work-worn fingers
into chests full of each others faults.
Once they stood mighty on fields of glory,
now they take turns digging ditch for the city.

And it comes home how much a road ghost
I've become, having to inhabit every
wherever I could lay my weary hurry down,

year after year blurring so I can't remember
if I lost the map of the dream way out west
or simply abandoned plan B way down
in that shotgun shack in New Orleans
when she gave the choice to jump the broom
or hit the road. So here I sit full-circled
on a bar stool, back at square one,
a few steps away from any of their shoes.

The ex-quarterback hits his buddy before
he goes out the door into crisp autumn air
with an invisible tight spiral—caught this time.
And the couple has given up arguing to cuddle
like maybe they could outlast the bad odds
of today's idea of wedding vows, while the man
at the end of the bar wakes up and says
her name again as if he hears it hanging there
for the very first time and like never since.

Song Heard Only Now After Gone

The Moon's Spare Change

Gritty drops from the El
water-torture after midnight streets.
A stumblebum follows along mumbling something
he wants, and I'm one step away
from the streets myself,
trying to figure how many dollars I'll need
for Destiny's garter as I make the last
round in this Great Lakes' port of call.
Daddy joined the navy, saw the world—
the South Seas anyway. I found snapshots
of taxi dancers sitting on his lap—
Jasmine, Rose, Lotus—smiling
in front of cardboard cut-out palms.
The drunk closes in through the murk, his lament
lost with the train's screeching departure.
In the cold breeze after-hush,
he holds out his hand sparkling
like he's been cleaning fish.
I spill coins through his fingers, jingling at our feet,
the moon's spare change.
Stale beer guffaws from the wide-open mouth
of a nearby bar as I walk on
past a warehouse loft circus where I see,
through a cracked dormer window,
a naked high-wire actress poised,
two steps from the other side
of her lover's bed. From the shadows,
A street walker shimmers out,
heels of thigh-high boots grinding broken glass,
a string of pearls gleaming
on damp breast. She smiles a gold,
diamond-studded tooth—footfalls,
the drunk again, ego doppelganger, I turn to meet him,
before turning back to her, then both are gone.
I sleep on a bench the rest of the night
beneath sodden newspapers, waking to blink

at dawn's coins melting
under my boots.

Song Heard Only Now After Gone

All night we sorted out love's loss
from a pile of photos like cards
for strip poker neither wanted to play.
We sat at the same table, the same bottle
of cheap champagne that first loosened
us to bliss standing between us, empty.
And no candles this time, no wives' tales
of sailors drowning in night swells. Just bare
light, two filaments a static burn apart,
and this song heard only now after it's gone.

Here's a scrap of the sea, a picture
of you from behind, naked, half-hidden
below a dune, staring out at the gray
sheet of the Atlantic under a grayer sky,
rising as a pale, sensuous flame in the sand.
You swam away the miscarriage every day,
the thunderous Cape surf shucking you out.
What would I hear if I pressed my ear
against your womb after all these years
but this song heard only now after it's gone.

I had already roved away like Odysseus,
always searching for the feast of arrival,
always a little in love with leaving.
On Naxos, in the middle of the Aegean,
I hoped to plant my oar in the ground of home
and proposed to another to a chorus
of lambent and inexhaustible waves.
Though we stood on the shore of the same sea,
I did not hear her and she did not hear me—
this song heard only now after it's gone.

"But not as deep as the love I'm in,
for I know not if I sink or swim,"
I sang before diving to the bottom

to find the perfect pearl for her earlobe
she could wear to show how much I cared.
Now I see how I always had that boat
provisioned and waiting around the next cove.
But don't doubt I still feel the bends
from being down in the blues so long
with this song heard only now after it's gone.

Tonight, far inland, I am all insomnia.
Train horns that echo through this small town
once called my boyhood dreams westward.
The rush of the highway fills the valley
with the metallic howl I've surfed half my life.
There's only an empty chair across from me.
My breath fills with bourbon and lonesome,
and my singing washes up memory's debris
making of the past, a presence of absence,
this song heard only now after it's gone.

Hunter's Moon

The Hunter's Moon highlights
the back streets of the Quarter
as I hurry to a party. It shines
Northwards over the frozen
cornfields rattling through Ohio,
poplar skeletons glowing along
Lake Erie's ice-locked shore.

But as I round the corner
to the hubbub of Bourbon Street,
night narrows to balconies
strung with gaudy lanterns,
laughter cascading balustrades
down to bawdy come-ons
of shills working the throng.

New Orleans gives permission,
to feel feral, all tongue and gut,
living it up, down and dirty,
centered in the hot-blooded
vertices of instinct and desire
as the solid world skirls up
into zydeco crescendo.

The moon's tambourine shivers
as he doffs his velvet top hat
and bows his skull in welcome,
offering a bowl of red wine
and this invitation to take off
the skin called sin, all the way
down to your bones and dance.

Heat Lightning

Missed-the-last-bus walk back
to an empty bed as heat lightning
singes the night sky like thought
through the haze of a three-day binge.

Hot, sweet and sour wind kicks up
alley way garbage; an empty body
bag scuds the sidewalk and a plastic
beer cup bounces chintzy bongo riffs.

Along the deserted, pot-holed street
a stretch limo slides its white length
past me staring in the mirrored windows
to an air-conditioned suite downtown.

Behind the hollow eyes of the rooms
above the boarded-up liquor store,
old men lay down in long stink
and sink far past even forgetting.

Once we blessed yes into each other
all night so there was no room for no
under a summer downpour whispering
into dawn drizzle over awning sleep.

Now there is only this dry-mouth trudge
up the trolley-less hill past the hospital
as first light begins to shape another day
dull-edged under a sky that will not cry.

The Night the Bed Became a Rack

The night the bed became a rack
mistakes ticked the brain-pan
through the third eye socket,
sight shucked out and flung into dark,
a sclerotic moon staring back.

I had nothing going for me but
breath, hearing how it wears out
the lungs, how the heart thuds
with suffocated blood, and just
as the spark blackened to ash

I inhaled dawn's sheer light
through the bars of bones and rose
and waded fully into my pulse,
crossing to that shore where I turn
to find I've always been here.

He Makes Them Come to Him

When the gardens are empty
at dusk, a gray-suited man,
his gray hair finely combed,
sits on a bench engulfed
by dozens of pigeons.
He makes them come to him.
They stop the rubber-necking
of their bloated courting
when he feeds them crusts
from the pocket of his coat.
They crush against his chest
from the perch of his arm.
They are soft and warm and coo
all over him, almost a body.
Their wings brush his face
like a woman's hand might.
He stands abruptly,
checks himself for droppings,
looks to see if anyone
was watching, and hurries away.
This is the third day
I have watched him do this.

Dandelions

Once upon the time of her change
she stared, enthrilled by the swirl
of the stream, the light startling
across as hundreds of minnows.

And there appeared a pond and swans,
and, on the other side, a mill.
She listened and suddenly understood
the constant downturn of the blood-wheel—

the pull and plunge, the suck and spurt
of the heart, a fish's mouth, and the crash
and splatter of new water over the bloom
of scum below until the stream runs dry.

She had a body and was no longer
above, alone, a princess in a tower,
pure and golden. She walked in the mud
on the bank and turned over heavy stones

to find and stroke the coppery sides
of earthworms, to catch the centipedes
dart of fire, to finger a lump of slime,
to smell her finger and taste it.

And the land greened and spread.
A plum tree formed ripe, and she bit
one after another, her eyes pressed closed,
the juice immediate through every vein.

Those plums full of yes. She sat deep
in the grass damp beneath her dress
she was never supposed to get dirty
as a crow landed next to her and cawed.

The edge of each sight started everywhere
expanding, overlapping like the circles
the sunfish make. Life was no longer a single
line you walk from girl to woman alone.

Then the dandelions of coincidence swelled
open, held and burst soft white spores
that scattered and covered the lawn like snow,
only to open into sun again and every summer.

Morning Walk in Late July

We've risen early, wash-clothed stale sweat
from our faces, breathed dawn and started off
before humid day slows and blurs our senses.

The summer has not become redundant yet.
Mauve clover and pale blue chicory glow
in the broken-window warehouse shadows.

Further on, rafts of Queen Anne's Lace hover,
ignorant of the graveyard of washing machines,
water heaters and pricker-choked toilets.

Around by the vacant migrant worker's houses,
Day-lilies stretch orange and bleach out saffron.
Your blond hair blends with the hazy light,

your cotton dress collages with touch-me-nots,
honeysuckle, trillium and morning glories
that you picked for a breakfast setting.

We cross the old river bed of the Hocking.
A sick creek is all there is that has not
flowed off somewhere else or evaporated.

But even this insipid current, rust-streaked,
gutted with bottle glass, still tells a story:
we listen and look back across and watch

two supple, tow-headed children bending up
in the long grass heavy with seeds, flinging arms,
threshing, then collapsing into the field laughing.

We look from them back to each other.
This morning the sun opens as many lucent
petals unfolding so there is never a last day.

Pop Songs Through the Night

In the middle of night
apartment complex,
empty elevators open
on lavender carpets
and long hallways sterilized
with fluorescent lights,
rock muzak and plastic plants.

Curled on the couch
under her mother's frowzy coat,
she would like to have a cat
to be pretty with and lounge
around yawning and petted.
But no one strokes her tonight.

Her voice wavered thin
through the phone lines
in the call that woke me
after I slipped asleep
out of an empty bottle
into my own red wine pity.

She knew as well as I did
I would be right over, driving
through the traffic light
that keeps making signals
all night, cars or not.

I pass windows that seep
blue light and rooms that stay
set and clean. Maybe a man
sits inside in the dark
sipping coffee or whiskey
or both deciding whether
to move or stay put.

I click on the radio and
a golden oldie fills night,
Imagine me and you, and
you and me so happy together...
and so on as I drive on.

In my teenage room,
I longed into every song,
ear pressed against plastic
transistor radio, antenna
pointed towards CKLW,
the Motown sound, crying
the tears of a clown
when there's no one around

I imagined snuggling close
to Denise at Big Boy Burgers,
sticking thigh to thigh
in the naugahyde booth.
I had no idea I'd ever be
released from the nervous,
glandular embrace of adolescence.

As I pass through this city
we have both drifted to,
I see there comes a time
neither of us will call,
having moved too often and
ending in too many other beds.

Some saccharine lyric will
make us want, once more,
to hold forever, because
One is the loneliest number—
the more cliché love becomes,
the more crucial.

Somewhere in the Midwest,
back in the heart of it all,
you will hear one of our songs
as it drones on and on
in an all-night donut shop
and start to hum along.

A middle-aged waitress
will take your order
snapping gum like you
learned back of the Tastee
Freeze summers ago.
She does not hum along.

She only wants to go home
to her double-wide trailer
have someone rub her feet
and call her, *honey,*
so long as it doesn't sound
through the rooms like *lonely*

The Ordinary

Another Monday another mundane
parade we join knowing it ends
in the ordinary where lines
in the face of the stranger
in the mirror mark the miles
shuffled and so much undone.
But outside, over the fenced yard,
across the street, a child begins singing.

Caught between the wind billowing
curtains and dishes in the sink,
you stare hard at the crumbs of bread
on the board and pieces of sky seen
through bare branches and return
to that empty parking lot,
chasing a gull feather around just
to cup the ocean in your hands.

We both bit into that fruit of desire
despite the worm crying *forbidden*.
Now we cut it into sections
of his and hers, throwing away
the core, forgetting the bliss
of gazelle eyes glazing over
in the lion's jaws, those tears
of surrender blending with blood.

So we fall into alone and
separate begets pain, begets
avoidance of pain and we live
for happy hour, braking only
for sirens, not ours, not yet,
pulling over, rolling down the window
to glimpse a red rubber ball
in the middle of a landfill.

Some days the sky is merely
the lid over what we must do
for the things we think we need
until suddenly it spreads wide
and we are standing in that field
catching our breaths, giddy and
dizzy as we kick that red ball
we thought lost so long ago.

Mr. and Mrs. Frankenstein

When you left you dumped
the skeleton from your closet
and the body I offered,
picked clean, into my lap,
your erotic experiment over.
Now I own all the broken
sex and desiccated shame—
you kept the fetish chains.

So I sort those bones and build
mine a bride of Frankenstein,
flesh both with rags of dreams.
They thud against each other,
groping to find human touch.
How they thrash around, outcast
from your *Body Immortal*
Tantric Palace where you escaped
into walls of mirrors, watching
how self-fulfilled you are,
and your guru's hairy ass.

But there's no Hollywood
ending for the Frankensteins.
On the way back to the heartland,
they passed Romeo's mansion.
Love never lasts in Beverly Hills.
Those adolescent monsters
nearly killed each other
with lawyers when Juliette
used Adonis, her personal
trainer, to get even with Romeo,
who was screwing his secretary
Trixie, a part-time porn star.

Not like Mr. and Mrs. Frankenstein,
as reliable a couple as the death

of spring, summer, fall, winter.
I saw them walking last night
in the rain with no umbrella,
arguing over which way to go,
him grunting in his clumsy boots,
her electro-shock soprano hairdo
soggy, but holding hands all the while,
their cold, green fingers entwined.

Letter From Andersonville

August 17th, 1864

Dearest Love and Baby,
 Above the deadline,
above the 15 foot pine stockade
measured daily with my gaze,
above the Rebel boys in their crows' nests,
I see the mountains of home.
Through chill winter drizzle
splattering our she-bangs and glazing men
more bone than skin
like God's gray-faced freezing tears,
I see the mountains of home.
Through the high summer sun blaring
over this scorched camp like Hell's bugle
blowing a mess of flies from its golden mouth,
I see the mountains of home.
My heart beats steps towards you
on the porch with our babe at your breast.

That you may not know my fate
torments my nights. I am safe,
but the hell here only grows
more crowded. The host of skeletons we present
is mirrored in the stares of the new prisoners
when they are shuffled through the gate.
The joke goes, it takes 3 of us to cast but one shadow.
We West Virginia boys congregate together,
scorned both by the Rebs, who calls us
the worst traitors, and by our Northern brethren
who suspect and mock our mountain lilt.
All feel sorely forsaken by the government,
yet I still feel this terrible swift sword just.
The freedmen here tell of tribulations worst
than we have endured in our hard times.
Oft times when hunger gnaws away hope
I make a meal of memories—your egg noodles

and fried chicken, o for a scrap of fat back
tossed to Argus, for one crumb of rhubarb pie
you wrapped in your kerchief the day I marched away.
Our rations are reduced again. Just mealy beans
and a crust of cornbread with the husk ground in.
All washed down with a fetid sip of Branch creek
make a recipe for dysentery. If not for the spring
that opened along the deadline after a thunderstorm,
many a parched soul would have entered the hereafter.
We have named it Providence Spring for truly
the hand of God has smitten this very ground.
I linger by its side after I take my draught
until the others roust me. Its clear flow
so reminds of the music of our creek.
We pray for rain daily that it cleanse this stench.
When it trickles round our hovels, the boys coughing
recalls tree-peepers, sounding a lullaby of sorts
for at least some still breath in this desolation.

Then the day dawns and the flies sort the quick
from the dead. To see a dear friend diminished
to a rag of fevered shivers clutching at nothing
tells of how much nothing abounds here.
Last night I dreamed a cluster of violets sprouted
near my palette, those Johnny-Jump-Ups I love so well.
I watered them with utmost care and looked up
to a field of blue-gray blossoms over rolling green hills.

O Love, one trill of the woodcock would whisk me
over these walls, over the harsh laughter
of the crows that circle these Georgia pines.
I swear I will walk these bones every mile
until I feel the mountains under my legs
as I climb towards you and our babe at home.
I pray it to be my last sight on this earth.
Your loving husband,
John

Song that Fathoms Home

A Burning Question

We didn't hear
the smoldering question
swirling over tar
pavement in the crumbling
red brick corner
of our playground
when we shouted
"Race riot! Race riot!"
circling and pointing
at black and white
incinerator fly ashes,
ashes we all fall...
It was Spring of '68
and Martin Luther King
and Kennedy's brother Bobby,
voices of freedom ringing,
were both shot down.
The dream never bloomed.
The fighting in the jungle
flickered on the evening
news, and my guts fisted
and churned like when
Sister Principal broke through
the ring of kids and lifted me
from the pavement where
I was pummeling that Polack
for calling me a dirty Mick.
She slapped both cheeks
back and forth screaming,
"Now is that anyway
for a Christian to act?"

There wasn't one black
kid at school except
the Italians, but those were
fighting words. Besides,

we were all Catholics
to the American kids
at Lincoln Elementary
who'd taunt us out
of our ties, but not
our scapulars into scrapes
on the street where we both lived.
The only black kids I met
sold peanuts out front
of Municipal Stadium
under grinning Chief Wahoo,
and those teenagers who
blurred across the screen
through burning buildings
when Hough was set afire.
That night I couldn't close
my eyes, I went outside
my hometown and looked
west for a glow in the sky,
over the hoods of East Cleveland.

II
The fire next time comes
as fists of blood pummel
though hearts faster as
Molotov cocktails skid
the streets and explode
into buildings fire-licked like
thermometers of rage
rising after the verdict.
It's an unhappy hour party,
getting back some get back
as the cops plan to take back
the city block by block
by national guard boots beating
double time on curfewed streets.
Meanwhile in Beverly Hills
they're holding their own

as greasy smoke tapers over
Hollywood like Hollywood
special effects, and looters
cradle six packs and cigarettes—
siege essentials—and 14 inch TVs
so they can watch themselves
running through the news later
for their 15 seconds of fame.
Outside the barred windows
it ain't just Boyz,
it's troops in da hood.
Bosnia burns next door.
The West Bank smolders
at the end of the block,
Belfast glares across the street.
And the angel of this next
seal does not come bearing
a book deal, but a flaming
shard of metal melting into
a question mark. No one will own
these movie rights and wrongs
as the American dream ends
again in a burned-out Korean
storefront on Jimmy crack corner
that stares like a killer child.
But that's old news now.

Memorial
for Jessica Krocza

War is just a word
far from these suburbs,
but not for her. Heroes,
here's a monument for
Dow Chemical's research team,
lab coats stained agent orange,
and Pentagon generals, orange
Nam campaign bars across chests.
Not a cold, metal-cast statue
to placate men who can't see
faces reflected in that black wall—
just a simple, floppy girl
born under a cabbage patch
scorched by the rusty cloud
sprayed over her father's daydreams
of home and nightmares of wave
upon wave of black pajama boys
dancing on the concertina wire
to the tune of jamming M-16s.

She's been twitching like that
every night ever since, neurons
misfiring like the kick of sidewinder
machine gun dubbed Puff,
the magic dragon, run amok,
tearing the jungle to shreds.
But the birds perched in her shriveled
brain can still slur together
the theme song of a purple
dinosaur on TV she watches
with a cross-eyed, 1,000 mile stare
inherited from her old man
popping open another beer,
drowning in the colorful jumble

on the screen to distract death
waiting the perimeter at Khe San.

Heroes, it's all happening again
for bright-eyed, clean cut Billy,
Gulf war vet who refused
to take the antidote for the chemical
weapon until the major ordered it—
and the scuttlebutt said, "we know
what they'll throw at us since
we sold it to them in the first place."
But in the last place, Billy can't sleep
or keep a solid stool, or rub two
thoughts together on the VA forms
even though headlines link that pill
to the syndrome - a year too late
for suicide Billy, spared the Pentagon's
plausible causes and further studies
as he joins the list of acceptable
losses on the spreadsheet.
Are the rig fires of Kuwait still burning?

No gung-ho monument can save
Billy, or this seizured girl Jessica
from stumbling down the steps
again and breaking her arm
in the same place again.
No burst of glory raising the flag
cracked her pelvis or chipped
her teeth into that snaggled
smile. Here's a salute, her arms
flipping rapidly when she's happy,
thudding dully as monsooned leaves.
How many times will she fall
for our fallen heroes? Here's a witness
who will not stand and rust.

Mutant Ninja Turtle Boy

The end is not near, but it is near here—
the backside of Worcester, a cold, gray version
of the last days of Pompeii, a rain of used junk
and discount store packaging having settled
in layers between peeling triple deckers
surrounded by freeways encircling Indian Lake.
Inside, Mom has given up on Judgment Day
for a better show on TV. She's trying to stretch
groceries till her next government check.
Her old man finally quit his job shoveling crap
against the tide and split to the land of dead-beat Dads.

"Hey Mister," says her son, wearing a dirty
mutant ninja turtle T-shirt, shivering arms
pulled inside sleeves so elbows stump out,
"Hey Mister," his eyes floundering on one side
of his face, his teeth jutting every which way,
blue pie or impetigo, or a bruise on his cheek,
"Hey Mister, wanna play war?" flipper pointing
to a pile of monsters and soldiers on hard-pan yard.

How many more plastic action figures need to be
sold before the scales shift and critical mass
spills, and the world becomes more garbage than
product, more product than raw material, more
material than spirit? God Money counts the good
of another gross of mutant ninja turtles,
the jobs they provide, the trickle down effect,
like the spit running from the boy's mouth
as he begs again, "Hey Mister, wanna play war?"

Cleveland Winter

Cleveland winter gray
from November till May
lake effect pall every day,
one stacked upon the next
like slabs in a steelyard.
Maybe a clump of weeds
smashed beneath stays green.

Grizzled, ashen faced
old bachelor uncle waits,
his cataract eyes watching
through fish-scale window,
for me to take him to soak
his Slovenian immigrant bones
in cinderblock bath-house.

Dawn's first dull light fills
the aluminum pot he hammers
into shape to hold his daily
ration of meals on wheels.
But when he stops, heat
leaves its skin, leaving
his hands raw and dingy.

He holds them over the stove's
blue flame like it's the last
blast furnace in the Flats
as the sun's molten smile
slides out from under clouds
before nails of thin sleet tap
down the sky's tin roof

Winter Sunset

Cursing *Winter,*
consonants cold
on teeth
as breath steams
warm over my face
like gauzy South Florida
thunderstorm clouds
misting through telephone lines
and turquoise neon signs
along highway A1A—

not the frozen plume
that hangs here in Cleveland
where everybody stays
battened down
from November till May
from the East side to the West side,
the whole city a rusty iron-ore freighter
locked in Lake Erie iced-over.

Cursing *Winter,*
again bundled inside
as I look out,
sharp vowels skirl
the windowpane, crystallize
into facets of sun
just as it cracks through
the cloud plates
so for a moment
it dazzles over icy streets

like the Atlantic horizon
seen from the end
of rickety Dania pier
just as 5 pelicans glide

no longer clumsy bodies
in a V
across the sunset.

City of Strong Thighs

Late morning, early winter,
windy Chicago intersection
near the Art Institute,
orange hard bats glaring
in cold sun as over-all clad
street grunts winch up
4x6 steel plates and swing
them over back-hoed hole—
dropped with diesal clang.

A woman with a coil of cable
looped around her shoulder
and jeri curls springing out
from under her hard hat
trudges past, stops, sips
coffee from a styro-foam cup
and squints up at something
while gusts lash gift bags
of shoppers hurrying by.

I follow her gaze to stainless
steel sculpture, a female figure
curving upwards, opening
at groin and heart to reveal
clear, blue sky beyond.
She smiles, nods and climbs
under the city of big shoulders
working her way through
the sewer department
on her own strong thighs.

The Last Ring Neck Pheasant

A willow wept profusely
on the plywood sign
for Grove Avenue Apartments,
a two story faded red brick wall
chock-a-blocked downhill
against the last wetlands
that held back the line
of progress a while longer.
Descendants of willows
once woven into baskets
by the Erie people
grew squat and broad
along the marshy bottoms.

After school, time became
careful steps picked through
thorns, asters, rusty tailings
and machine parts from the shop
across the swamp that echoed
punch presses round-the-clock
from its corrugated steel shell.
I grew used to the noise during
searches for that red fox
I glimpsed as it flashed
into the wall of fall weeds,

until one evening a ring neck
pheasant fluttered out
full length before disappearing
into a thicket of red prickers.
Its splayed wings and shining
tail caught the last light
before another day got hammered
down into a metal drum.

The Picture in the Shoe-box

Coming home confused after two straight years
of work and before starting yet another life,
I search in the stifling air under the ribs
of that last attic for the shoe-box, to turn
over in my hands, things that bring back my father.

I remember just where I put it, only it's gone now.
Nothing there but pinches of wood-rot spaced
across the floor, a wad of newspaper packing,
a bit of spider chaff on the one, square window,
and a blue bottle fly bouncing against the pane.

But no worn-out wallet never full enough for
bill collectors; no ungiven business cards;
no salesman's 10,000 mile plaque for trips
that stretched over weeks of family dinners;
no watch that kept his heart-attack on schedule.

No shriveled four-leaf clover trapped in plastic;
no portrait of JFK, hero he modeled his haircut after,
no boyhood fishing rig, how I would unwind
the frayed twine and study the hand-carved lure.
No tap from the piano bar he was too broke to open.

Nor any pictures flat on the bottom of the box,
faces of Navy buddies no-one recalls but him;
and not that photo of him in a group of fishermen,
a young man out at sea holding up a blue-fin tuna.
How I imitate that smile and bare-chested stance still.

I pick up the wad of newspaper, flatten it out,
check the headlines and scan the yellow skin.
But it was an uneventful day, same as this one,
only the usual sales, box-scores and troubles
unconnnected to his life or death, just packing.

No doubt somebody's death was reported there,
that small plot allotted, overturned the next-day
and filled with another beloved father...
maybe someone related to the man who took his place
at work, who set-up other photos at his desk.

A few years from now more of our lives will be boxed
and stored here where a square of sunlight paces.
A few years later, when another family moves in,
one of the boxes will be lost or left behind
and they will search their dreams, waking before it's found.

And I walk up to the house where we once lived
and decide not to knock, but before turning away
I glimpse the family around the table, a gray-haired man
reading the paper, a woman cleaning the plates,
a younger man home for visit. No talk between them.

As I walk away, I add that picture to the shoe-box,
along with those men who punched the clock
till they dropped or retired, who posed, strong
and vigorous, with a big fish reeled up from the deep
they would divide and remember for years after.

Song That Fathoms Home

Summer come this stretch of river would thrum our veins,
every riffle, deep slough and lazy eddy
from the town dump, through the crumbling shale cliffs
to the cool, green roil below Daniel's Park dam,
as we were drawn to that crashing power
that pulled you under all these years later.

You loved this river, lived by its side,
swam these currents as sinewy as rapids flexing over boulders,
and stood up one big-armed embrace
of arctic winds through Alaska's thrashing straits,
leaning over trawler edge
to brave salmon hauls,
laughing in the teeth of cold, salt spray.
A man's man, you died a man's death.
I don't say a good death. I say a man's death.

Now after Spring floods, the Chagrin subsides
its muddy churning that carried you away.
Eastlake teens swig canned beer and bow-fish carp,
skewered bodies rolling like drowned suns.
One heron sentinels the shallows,
letting only the shadows of the boys of summer pass
Wally Leoni, Italian hill-kin,
white-legged from wading all summer,
who canoed the Hocking to the Ohio to the Mississippi
alone all the way to New Orleans,
hermitting a cabin above the Ocoee now.
John Casini, maybe still in an institution,
whose simple strength snapped the taunt from a kid's neck.
How these poplar leaves fluttering
like a school of green fish
would calm him, and you, Mark, broad shouldered daredevil.
The buzzards soar high today, the last of the wild
to wheel away over another field of condo developments.

May the river devour these private property signs.
May the kingfisher skim open the seam of day's surface.
May the killdeer's skittering cry among the shale banks
greet your children's children when they come to skip stones.
May they trace the swerve of cliff swallows on the waft of
 evening
and respect the dark waters rising.
For the river will swell and rage and calm and hum
this song that fathoms home.
And the river will wash away these lines
as the river laves everybody's name, Mark,
with such a hush-a-bye.

O The River of Light
flows cool and clear;
I once was scared,
but now I know no fear.
We're already on
that calm and peaceful shore.
We live here everyday.

O The River of Light
flows fresh and bright;
I once was blind,
but the waters gave me sight.
I once was lost,
but found that other shore.
We live here everyday.

O The River of Light
flows through the night;
to swim its deeps
is to respect its might.
We're already on
that far off, starry shore.
We live here everyday.

The Definition of Making a Living, Part 2

The digital alarm flashes
HA-HA-HA-HA-HA,
time to report for duty
humping the grind—
it's a shift job, it sucks,
the tool and dying refrain.
Outside the sooty window
the alley leads to rush-hour,
legs jack-hammering
pavement, arms pumping
off we go hi-ho to the land
of dwarves and machines.
I AM IRONMAN! heavy metal
rage against the machine
pistons the burnt-out brain.
At least this new job is better
than filling bags of fertilizer,
behind a plastic respirator.

But this is what a GED
will get you nowadays,
knocking apart pallets and
putting them together again.
Pallets to put stuff on,
fork-lift out of warehouses,
pack on trucks and haul it
to discount store docks
where it's stocked on shelves
so folks can buy, use
then stick the stuff
in garage storage units.
And just what is the stuff?
Everything TV says to buy
now, pay later, might as well
pile on the debt, pal,
you can't take it with you.

But at least you're working
with your hands—it takes
3 minutes, usually, to take
a pallet apart, but if
it's got 5 flaws, if 5
of the boards are broken,
cracked, chipped, rotten
or missing, trash it.
But if it's only got 4 flaws,
it's a decision, plus,
the work, but mostly
a decision about the work
which means you got to
work and do the math.
If it only has 3 flaws or
under definitely fix it—
'cause you got to hit
your quota and then some
if you want a raise so
you can get your own stuff.

There's no easy reservoir
of gravy to draw from.
It's not even raining burnt
manna, just a Pompeii
of used junk in the backyards
of the poor which are
the backyards of the rich
which are the backyards
all the way back to whoever
eyeballs us from the top
of this pyramid scam.
And your resume reads,
It's a shift job— it sucks,
as you try to keep your head
above the tide of crap,
by clinging to that pallet

as the land sinks under the STUFF!
Meanwhile the steroid boys
can't wait to leave their offices,
pump iron at the gym then
go drink scotch and smoke cigars
like latter-day robber barons.

And the labor pool health plan
is luck, and don't get sick, or
hung-over slip and mash
your thumb to bloody pulp
so the boss says, *I guess*
this means you're done
for the day? Wrap a rag
around it and drive your ass
to the ER. I'll pay. Don't
put it on comp. My rates
will go up. So you wait
in the lobby since you've got
no papers, your thumb throbbing
It's a shift job— it sucks.
But a week later, shooting hoops,
you take that double SOB
for twenty bucks, *Cough it up,*
so I can get drunk, and guess what,
I ain't buyin' you a round.
Yeah, it's a shift job— it sucks.

A Swampwater Cocktail

For Jimmy Nolan

Somnambulating
from sheet-soaked torpor
into August afternoon swelter,
the clear trill of a mockingbird
wakes me
 as I look for it perched
on a bleached, dry-rot telephone pole,
one mast of this raft of shotgun shacks
moored on the back streets of Bywater
under a sepia sky.

I'm plumb below
sea level, below even
the Mississippi levee,
a good three stone's throw away
from its cafe au lait flow,
the ground buoyant underfoot.
"A Bus Named Desire"
somehow doesn't sound the same
sultry rumble as it shudders past
along crumbling Dauphine Street
in a swirl of grit and diesel.
From its windows, the women wear sour
'don't mess with me, Honey,' faces,
braced for their trek
through the notorious 9th ward.

Creole Marigney plantationed here
around the crescent
with slave labor.
His wastrel son sold parcels, piecemeal,
to pay off French Quarter gambling debts—
hence the first sub-division,
or so real-estate agents claim.

Now working folks, bohos, ancient jazzsters,
yellow fever haints and drifters stay
hunkered down together in this side-
eddy of the Big Sleazy.

As I glide on, legs like poles
pushing a bayou flat boat.
the mocking bird calls again
through the kiln of the sun
that bakes the funk and decadence
of Esplanades gilded porches, sagging
lintels and warped shutters
shut for good, faint aspirations inside,
dreams termited.

Crossing the Elysian Fields divide, I unwind slow-
motion along the shady side,
live oaks dripping moss
like old money.
Behind the Quarter's wrought-iron gates,
green tongues gleam,
fronds allure languor,
and filigree arms beckon me
to settle into cool fountain,
pretend Eden garden,

where I sip a swamp-water cocktail
flecked with duckweed,
feeling fine
roots of being sprout
seeking mud and leaves of skin
open pores. I lean back waiting
for that one breeze
due sometime soon
as I seep into one
heavy exhale.

The Bottom

I'm sick and tired
of sayin' I'm sick and tired
of bein' sick and tired.
I could tell you all over
how I've woken up
next to some snoring pig
and swore, and swore
I wouldn't do this anymore.
But 8 hours later,
I'd be back at the bar for more,
forgettin' all about
gettin' up disgusted
with somebody worse off
than me, or even worse
some Dick who forgot my name,
who couldn't look me
in the face. Or worse still,
alone in my own puke
so fulla sour empty
I'm a bug. A crud. A turd.

Ever see somebody puke
their guts out? Wait 5 minutes.
I guess you gotta swallow
a hellofa lotta vomit
before you get sick of it.
But I'm sick of talkin'.
Almost as sick of talkin'
as I am of drinkin.'
You wanta talk about sick-
how 'bout a support group
for women who've been screwed
by their shrinks?

They say come back
when you hit the bottom.

How the hell do I know
when the hell that is?
Like when I was kneelin',
huggin' the crapper, and flushed
my whole lift down it.
Includin' a baby.
I didn't even know
what it was. A miscarriage.
I was so shit faced I thought
it was just a heavy flow
except for this little
flap of skin. I pinched it
and rolled it between my fingers.
What was I supposed to do,
put it back in there?

I didn't ask to be here.
I don't want to be here.
I want to disappear. There's nothin'
I crave more than for this hell
to be over once and for all.
What am I supposed to do,
crawl back up in the womb
wrap the umbilical cord
around my neck and ACK!?

I don't know why people
end up down here anymore
than you do. What's the sickness
behind the sickness makes us
do this to ourselves over and over?
Why do we need need?
I guess I ain't hit bottom yet.
I might be dead before I do.

Harold's Resurrection

Harold holds forth
about God to his friend
as they pass the bottle
back and forth on the bus:
There's a god all right,
all over the place.
I was down in the snow
stabbed seventeen times,
hovering over my body
closing up shop big-time.
I drifted a little this way
and that like a smoke ring,
then got vacuumed up.
The stars were flying by
zip, zip, zip towards a big
blur of more light
than when you wake up
hung over in the tank.
Then I heard my mama.
"Harold, what's wrong?
What are you doing here?"
And I came back and woke up
in the snow with seventeen
holes in me. Here's one,
right here in my neck.
Harold's friend says,
you wasn't dead,
you was only dreaming.
And Harold says, *Hold on.*
I think I know the difference
between dreamin' and dead
since I done it and I thank
God who is everywhere
even on this here bus
for bringing me back to life.
How do you know I'm not

God then? his friend asks.
Because, and I want you
to listen close to this,
I can kick your ass.
And Harold's friend nodded.

The Devil at the Mall

They have the devil on display
at the new mall,
scaly leg chained
to a gold cage
at the bottom
of an escalator
below the body lotion shop
near the fountain
where no penny toss
is allowed anymore.

Shoppers crowd closer
as he glowers, stroking
his tail, split tongue flicking
around eye sockets,
heart valves and secret tunnels.
One guy hits him
with a coin right between
his twelve inch horns
to impress his fiancée,
and the devil rears over-top
the bars and swallows him
up to his waist and
spits him out—slimy,
embarrassed smile, the guy
chings in all his change,
empties his wallet, the dead
presidents fluttering down
like hamster chips.

Customers come to gawk till
the devil is passé.
Once in awhile this
longhaired, homeless-looking guy
shows up, keeps
his distance, and harangues

the food court *–Look*
in these golden mirrors
for your bar codes!
before rent-a-cops escort him
off the premises.
Shoppers chuckle and return
to fast-food small talk.
But he's back again, shouting,
There is no real
estate! One heart beat blasts
private property
to freedom come!
As security drags him
away, the devil's laughter
rattles his cage.

Last Will and Testament for the Millennium

Free Speech? Free to pitch in my 2 cents worth
against the falling walls of Babylon
amidst the cha-ching for the bling-bling
here at the 2-minute warning of the Apocalypse.
But how much dead air will that buy
on the nightly news as 300 million screens
of straight-faced talking heads
monotoning the latest blood spilled rain
down over playgrounds of children pointing
remotes at each other and clicking
like they're targets in smart bomb sights?
And business is booming at the bullet factory,
while down on Wall Street for the last decade
speculators shot their loads, popping champagne
over the pit at the bell as the bubble swelled
over 10,000 for the first time like a soufflé of greed;
meanwhile a medicine man got lightning bolted off a tin roof
trying to conjure a cloudburst in the middle of this drought
where the pursuit of happiness finally ended today
when the last consumer in line, clutching the last
withered dollar bought the one more thing–
a Beanie Baby, a superhero action figure, a dirty bomb–
that tipped the critical mass of what's left
to be made of the earth and sold
into a pile of Gross National Product that overloaded
the chip inside everything
so the Ludites' web-page crashed
before it could be emailed an obituary for the rain forest,
glowing green numbers flickering out.

And the man on the street yells, *Y2 what? KY2 you!*
some lube for the screw job we're getting again.
The stock market rises and falls, and we're still
shoveling crap against the tide.
And the woman on the corner lifting her baby,
clutching a bag of groceries, trying to catch the last

bus out of town is too busy for doom
or hope as suburban gang-bangers full
of grand theft auto-erotic fantasies,
slinging body count slang, drive by
in an SUV riding the exhausted soundtrack of Armageddon
let loose by a Hollywood exec
slamming the books on a bomb
about the end of the world that could not beat
the competition at the box office, as the Capital
politicians promise to take sex and violence out of the movies
and put it back where it belongs
in their pants and the economy
as they calculate how much they can make
in the final bargain before
THE CLOSE OUT SALE OF THE CENTURY!
EVERYTHING MUST GO!

So now as we gather around the crater of the 20th century,
I offer this last will and testament
to give back what has been given to us:
this clock of progress minus numbers
that numb the moment or arms that cut life to the quick,
may its blank face reflect only
sun, moon and starry night;
this coin imprinted with the soul of man sold,
may it be rubbed smooth by fingers no longer needing greed;
this scraggly ragweed cracking city sidewalks,
may it bring insurance skyscrapers to their knees;
this atomic mobile hung over every newborns' crib,
may Hiroshima blossoms never again bloom;
this glass eye uncovered in Auschwitz ashes,
may it stare down all final solutions;
these skulls full of fetid tears heaped in mass graves,
may they be cracked into a storm of lamentations
cleansing every ethnic killing field;
and this river of history clotted with burnt stumps,
bloated bodies, and wreckage of empires,

may it flood and flow clear through every heart
that beats once and again and always
what comes and goes as human.

Beginning With Being

Beginning with being, and rolling with roles
played and leaps beyond doubting doubt,
stand still and behold the tall hallelujah of all
and the HA echoing HA empty night

unto this pulse between dream and shore
where original elders turn worn faces windward
and grandchild whistles sand through hands
reminding the vow "to be" sounds always now—

so long as you're not stuck on line screwing lids
on jars of air and stamping BEST IF USED
before last breath, or walking out into a fire-fight
the target on your head right between their sights.

One only lives once and it's forever, a spiral
nebula the child rides forth from primal
into tidal pool where the moon's bony fingers
knit a skeleton around this pulsar lingering.

So ponder Daddy Death's sun-bleached smile
wreathed in Mother Earth's trembling blossoms,
mirror of departed returning from tomb
as face of newborn squirming from womb.

Under these guises we take our places giving voice
to ancestors whispering lore, saying "live" so close
to bone it sounds "love," begotten from a dance
of communion as much as lust or circumstance,

engendering an extra in the crowd scene,
the hero with flaw revealed, the villain redeemed,
the has-been that never was, the shooting star,
the nobody who smiles on success and failure;

the doomed warrior who answers the call,
the prophet who shuts up and doesn't scare a soul,
the mourner in the ruins, the dancer in the rain,
the travelers arriving at destination is hallucination.

Not a human drudging but being, hewing
to the eye of the tornado of yes and no,
foregoing the hungers and fears of ego
to follow the callings of bliss always new,

I hang up the tragic mask with a laugh,
hang up the comic one with a tear,
and take off the fashions of the day I wear
to the bare forked truth of ordinary life,

and offer variations on the one tongue,
tuning the pitch of these lines into a fugue
that hums the names of things into airy nothing
as I bow this shadow and join the starry night.

Ray McNiece has earned a national reputation as a poet and performer for almost two decades through his solo theater pieces, his poetry and music shows, his captaining of two National Poetry Slam Championship teams, his "edu-taining" children's shows and workshops, and his yearly country-wide tours of performance poems, stories and songs.

The Orlando *Sentinel* calls Ray "a modern-day descendent of Woody Guthrie. He has a way with words and a wry sense of humor." In a review of his second solo theatre piece, *US?—Talking Across America*, *The Star-Phoenix* said, "His thoughtful writing combines with perfectly timed delivery to create a powerful wordscape that owes as much to jazz as drama."

Highlights of his tours include a keynote address with Robert Bly at the First Coast Writer's Conference, a featured reading at the opening of City Lights Italia in Florence with Beat poet and editor Lawrence Ferlinghetti, and a performance with his band Tongue-in-Groove at the Starwood Festival, opening for legendary African drummer Babatunde Oluntunje. In the summer of 2000 he toured Italy with Anne Waldman, John Giorno and Ed Sanders as part of the City Lights Italia Festival. In the summer of 2001, he performed in Moscow, at the Polytech, the Russian poets Hall of Fame, and in Zima Junction, Siberia, with Yevgeny Yevtushenko. While there he performed on "Good Morning Russia."

Ray is the author of four books of poetry, two solo theatre works, two music/poetry shows and several theatrical collaborations including *Homegirl Meets Whiteboy* with Shawn Jackson in 1994. *Dis–Voices from a Shelter* was produced by WGBH and aired on PBS in 1989. He was the 1999 Grand Slam Champion of the Arkansas Celebration of the Arts, the largest performance poetry prize ever awarded. He received the 1999 Award of Excellence for his writing from *Northern Ohio Live* and won the 1999 Lyricist Review Song contest. He chaired a panel on performance poetry for the 2000 National Folk Alliance Conference and was an honored writer for the 1998 and 2000 Writers and Friends Celebration sponsored by the Poets' League of Cleveland.

In 2001, McNiece was awarded an artist residency at the Cuyahoga Valley National Park, and at the Kerouac House in Orlando in 2002. His song, *I Can See the City*, was featured in the WVIZ documentary *Faces of Steel* (2002). He was the voice of Woody Guthrie for National Public Radio's Documentary *Hard Traveling* which has aired every Labor Day since it premiered in 1999.

****** Working Lives Series ******
Bottom Dog Press
http://members.aol.com/lsmithdog/bottomdog

Robert Flanagan. *Loving Power: Stories.* 1990
0-933087-17-9 $8.95

A Red Shadow of Steel MIlls: Photos and Poems. 1991
(Includes Timothy Russell, David Adams, Kip Knott, Richard Hague)
0-933087-18-7 $8.95

Chris Llewellyn. *Steam Dummy & Fragments from the Fire: Poems.*
1993 / 0-933087-29-2 $8.95

Larry Smith. *Beyond Rust: Stories.* 1996 / 0-933087-39-X $9.95

Getting By: Stories of Working Lives. 1996
eds. David Shevin and Larry Smith / 0-933087-41-1 $10.95

Human Landscapes: Three Books of Poems. 1997
(Includes Daniel Smith, Edwina Pendarvis, Philip St. Clair)
0-933087-42-X $10.95

Richard Hague. *Milltown Natural: Essays and Stories from a Life.* 1997
0-933087-44-6 $16.95 (cloth)

Maj Ragain. *Burley One Dark Sucker Fired.* 1998
0-933087-45-4 $9.95

Brooding the Heartlands: Poets of the Midwest, ed. M.L.Liebler. 1998
0-933087-50-0 $9.95

Writing Work: Writers on Working-Class Writing. 1999
eds. David Shevin, Larry Smith, Janet Zandy / 0-933087-52-7 $10.95

Jim Ray Daniels. *No Pets: Stories.* 1999/ 0-933087-54-3 $10.95

Jeanne Bryner. *Blind Horse: Poems.* 1999 / 0-933087-57-8 $9.95

Naton Leslie. *Moving to Find Work:* 2000 / 0-933087-61-6 $9.95

David Kherdian. *The Neighborhood Years.* 0-933087-62-4 $9.95

Our Working Lives: Short Stories of People and Work. 2000
eds. Bonnie Jo Campbell and Larry Smith / 0-933087-63-2 $12.95

Allen Frost. *Ohio Trio: Fictions.* 2001/ 0-933087-68-3 $10.95

Maj Ragain. *Twist the Axe: A Horseplayer's Story* 2002
0-933087-71-X $10.95

Michael Salinger. *Neon* 2002 / 0-933087-72.1 $10.95

David Shevin. *Three Miles from Luckey: Poems.* 2002
0-933087-74-8 $10.95

Working Hard for the Money: America's Working Poor in Stories,
Poems, and Photos. 2002, eds. Mary E. Weems and Larry Smith
0-933087-77-2 $12.95

Eclipse: Stories by Jeanne Bryner. 2003 / 0-933087-78-0 $12.95

Alive in Hard Country by Richard Hague 2003 /0-933087-83-7 $12.00